D0116010

APR - - 2015

99 PROBLEMS

99 PROBLEMS

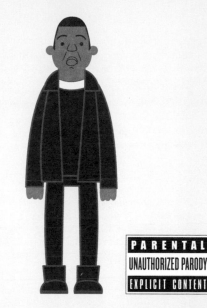

PARENTAL
UNAUTHORIZED PARODY
EXPLICIT CONTENT

Superstars Have Bad Days, Too

written and illustrated by

ALI GRAHAM

WORKMAN PUBLISHING • NEW YORK

Copyright © 2015 by Ali Graham

All rights reserved. No portion of this book may be reproduced—
mechanically, electronically, or by any other means, including
photocopying—without written permission of the publisher.
Published simultaneously in Canada by Thomas Allen & Son Limited.

Library of Congress Cataloging-in-Publication Data is available.

ISBN 978-0-7611-8215-3

This book is neither endorsed nor sponsored by any performer.

Design by Becky Terhune

Workman books are available at special discounts when
purchased in bulk for premiums and sales promotions as
well as for fund-raising or educational use. Special editions
or book excerpts can also be created to specification.
For details, contact the Special Sales Director at the address
below, or send an email to specialmarkets@workman.com.

Workman Publishing Company, Inc.
225 Varick Street
New York, NY 10014-4381
workman.com

WORKMAN is a registered trademark of Workman Publishing Co., Inc.

Printed in China
First printing February 2015

10 9 8 7 6 5 4 3 2 1

CENTRAL ARKANSAS LIBRARY SYSTEM
SUE COWAN WILLIAMS BRANCH
LITTLE ROCK, ARKANSAS

INTRODUCTION

We've all got problems—you, me, your friends and neighbors, even that guy you're silently cursing for cutting you off on the highway . . .

Ranging from minor annoyances to full-blown catastrophes, problems have been part of life since the dawn of time. The dinosaurs had that pesky meteor, the Trojans had that bothersome wooden horse, and right now you can't decide whether you want to read this book or watch hilarious cat videos. (Both worthy endeavors.)

They say that if you're lucky, you can count your problems on one hand. But someone—was it Shakespeare?—also observed, "Mo' money, mo' problems." It's a sentiment as true now as it has been since currency was invented. No matter how much fame, fortune, and success you may have, problems are unavoidable.

The song "99 Problems" covers this very subject, and it inspired me to start a Tumblr where I could explore the problems a certain top hip-hop artist might face, in contrast to the problems of everyday people. I started looking to the rest of this superstar's body of work for further inspiration, and after 99 days I had 99 illustrations. You will find some of those originals, along with some brand-new pieces, here in this book.

And that brings us to right now. You may have heard of one particular man who endured more sticky situations than there are hours in a day, and faced more dilemmas than there are squares on a checkerboard. This is his story.

PROBLEM #1

CAN'T GET DIRT OFF SHOULDER

PROBLEM #2
WHERE BROOKLYN AT?

FRIEND REQUEST FROM GRANDMA

PROBLEM #4
NOTHING RHYMES WITH *ORANGE*

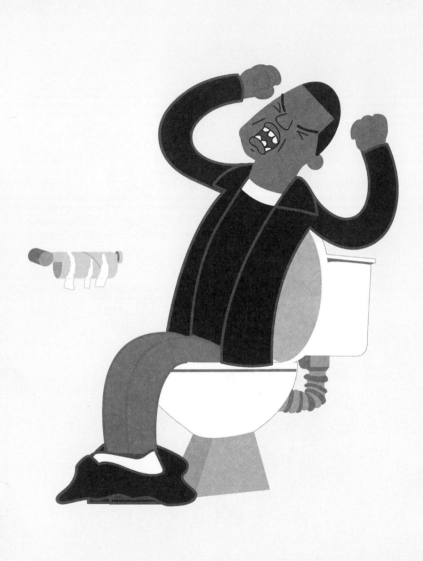

PROBLEM #5
OUT OF TOILET PAPER

PROBLEM #6
HARD TO FOLLOW
THE BLUEPRINT

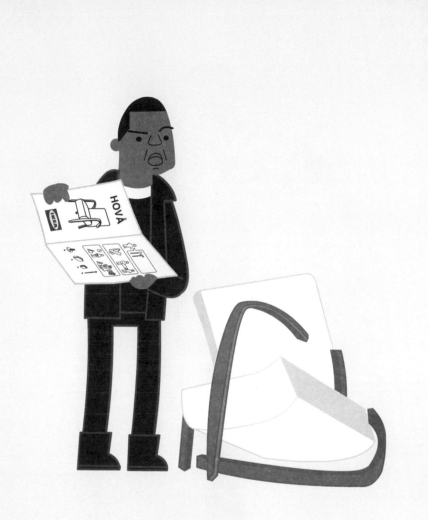

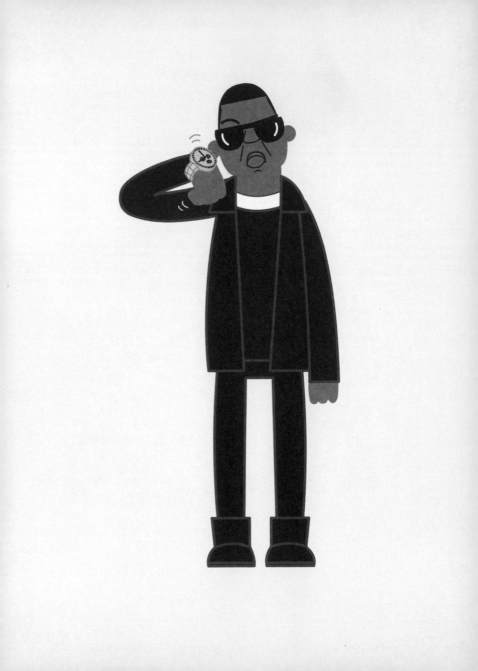

PROBLEM #7
ROLLEY DON'T TICKTOCK

ONE LAST TIME, I NEED YOU TO ROAR

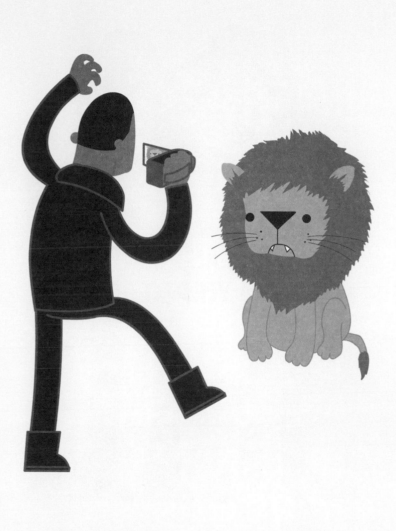

PROBLEM #9
I'M NOT LOVING IT

APPETITE FOR BRAINS

PROBLEM #11
SHE'S A SURVIVOR

PROBLEM #12
DIGGERS IN PARIS

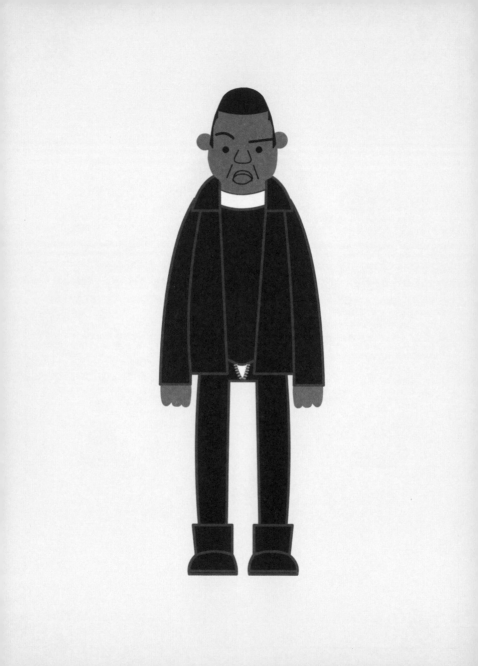

PROBLEM #13
ZIPPER'S DOWN

BROKEN UMBRELLA
(ELLA ELLA)

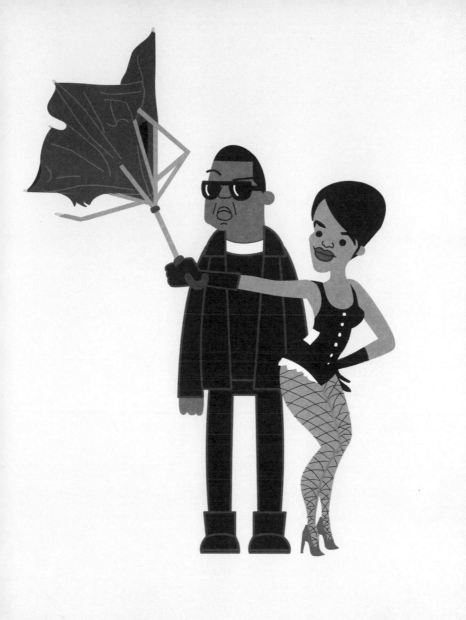

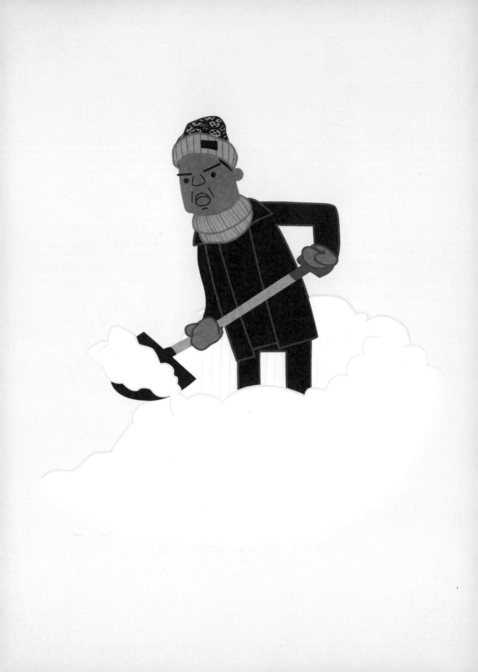

MOVING SNOWFLAKES

PROBLEM #16
SOAP IN THE EYE

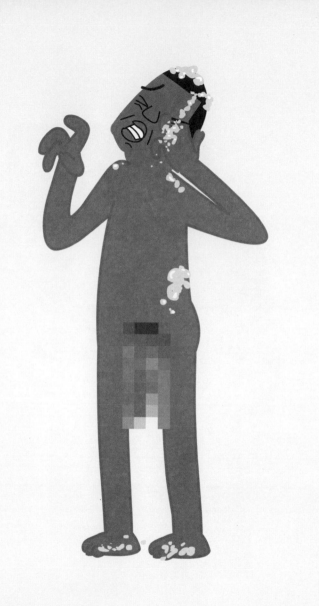

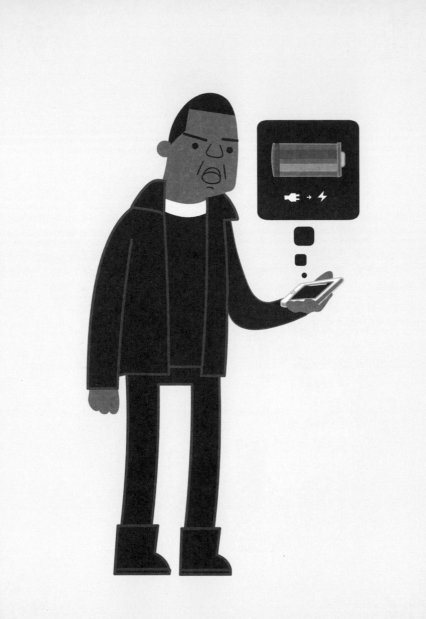

PROBLEM #17
LOW BATTERY

HARD-KNOCK LIFE

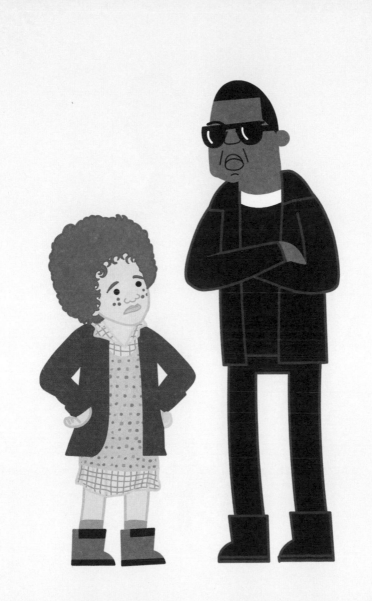

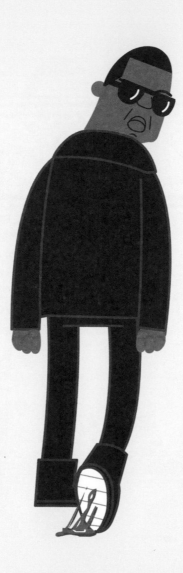

STEPPED IN GUM

BAD BATCH

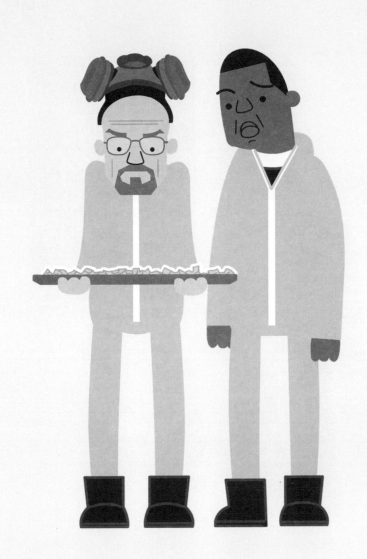

KEEP CALM AND RUN THIS TOWN

PROBLEM #21
UNIMAGINATIVE BRANDING

POISON APPLES

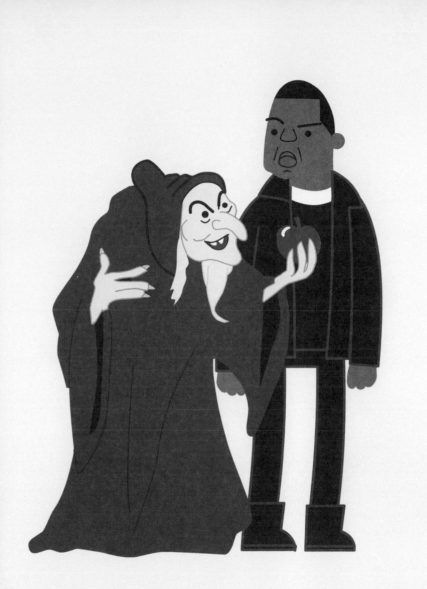

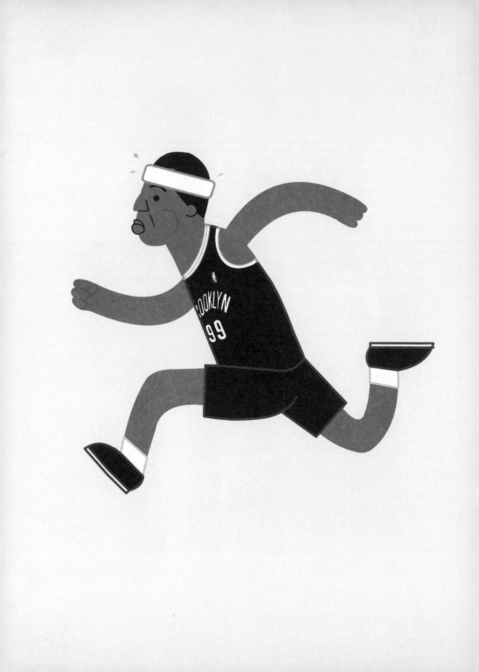

PROBLEM #23
ON THE RUN

PICASSO BABY

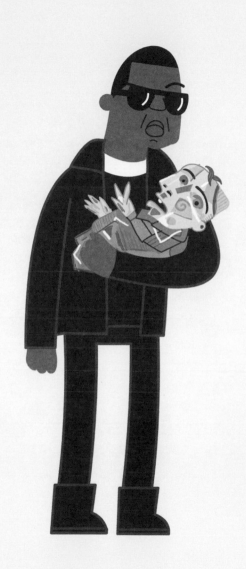

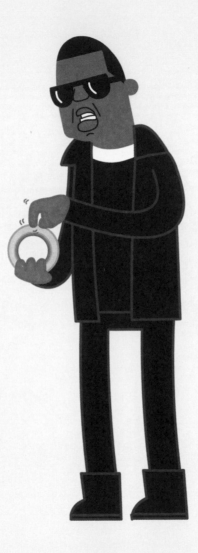

FINDING THE END
OF A TAPE ROLL

FEAR OF FLYING

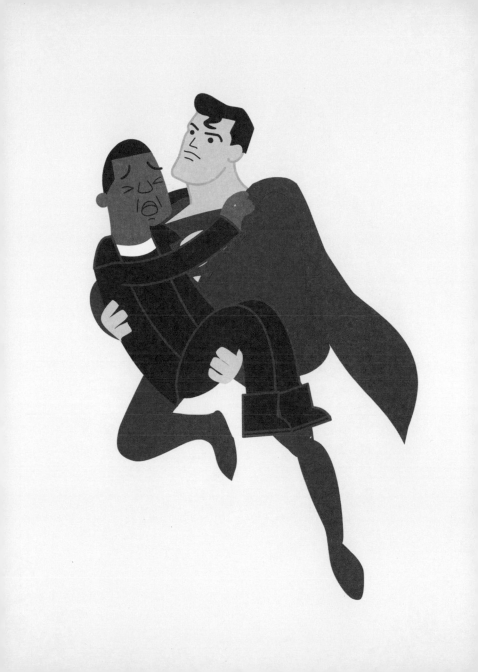

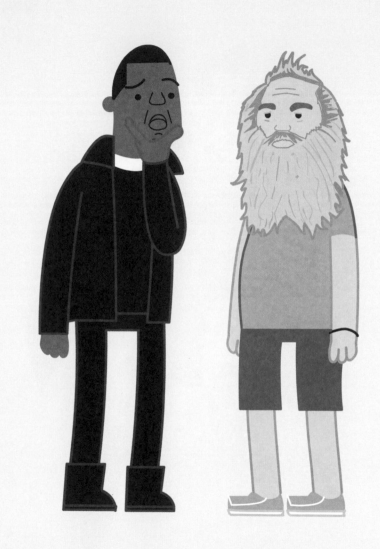

PROBLEM #27
BEARD ENVY

AUTO-TUNE

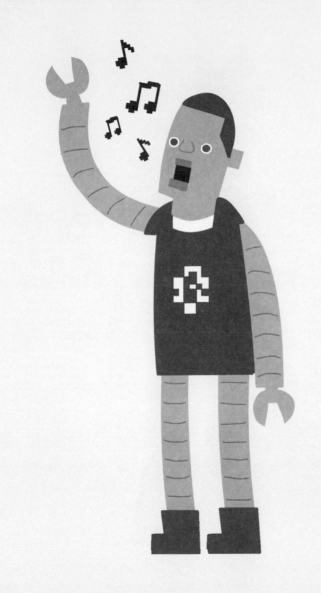

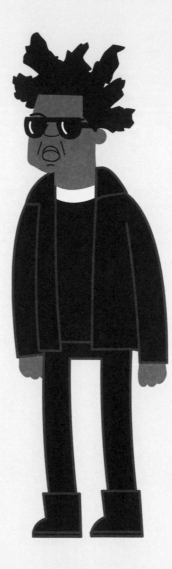

PROBLEM #29
BAD HAIR DAY

PROBLEM #30
POOR TABLE SERVICE

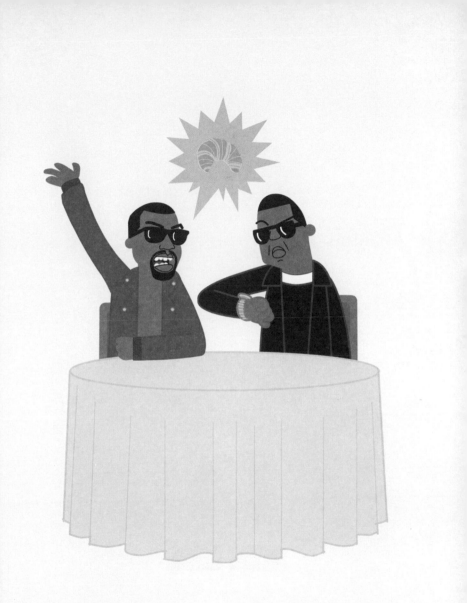

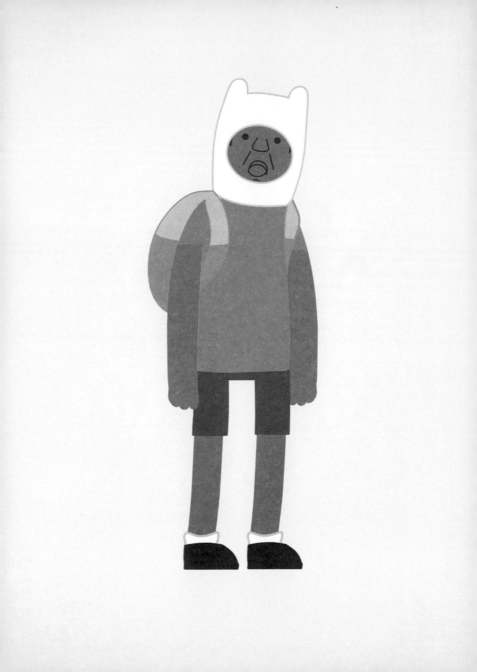

PROBLEM #31
NO TIME FOR ADVENTURES

MY ONLY OPPONENT
(THE MIRROR)

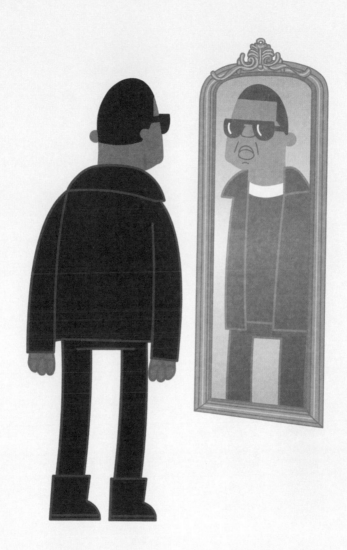

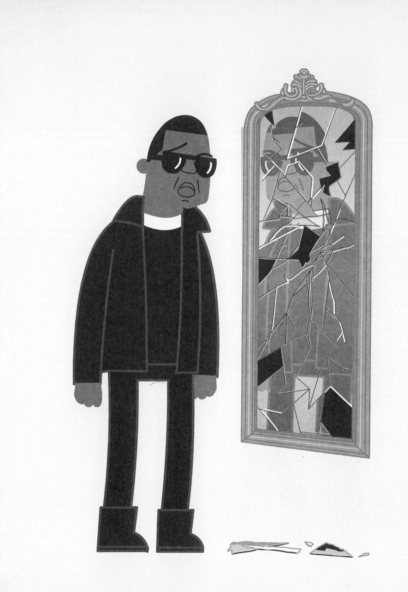

PROBLEM #33
BAD LUCK

PROBLEM #34

SCREAMING YOU LOVE ME LOUD

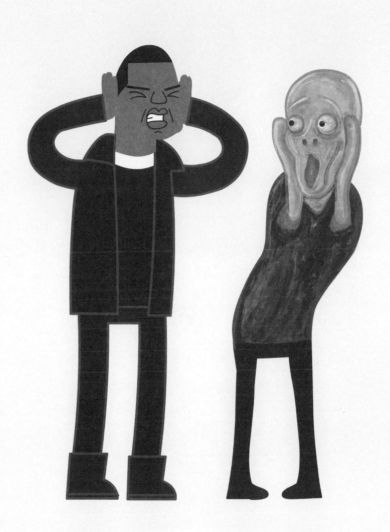

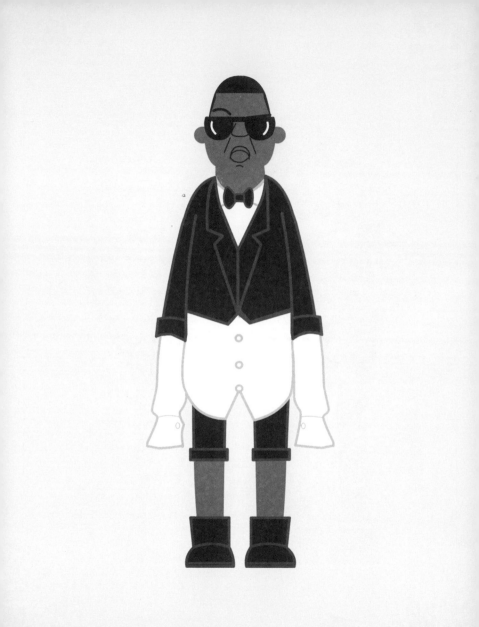

BAD TAILORING

PROBLEM #36
RED WEDDING

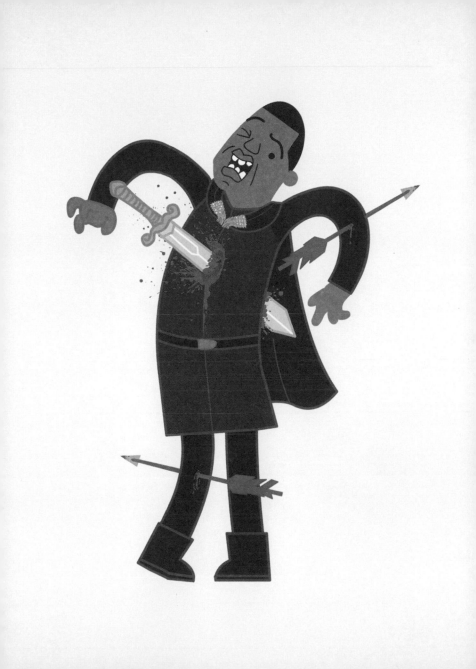

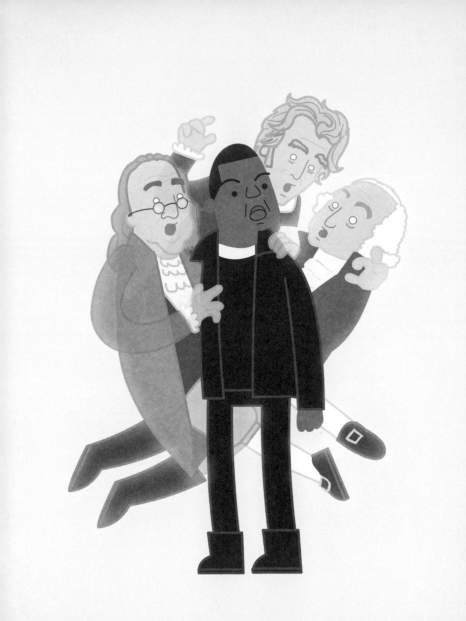

PROBLEM #37
DEAD PRESIDENTS

PROBLEM #38
NUMBERS DON'T LIE

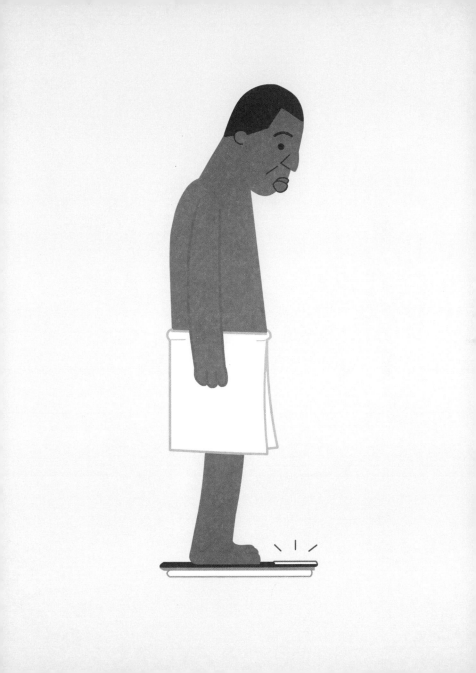

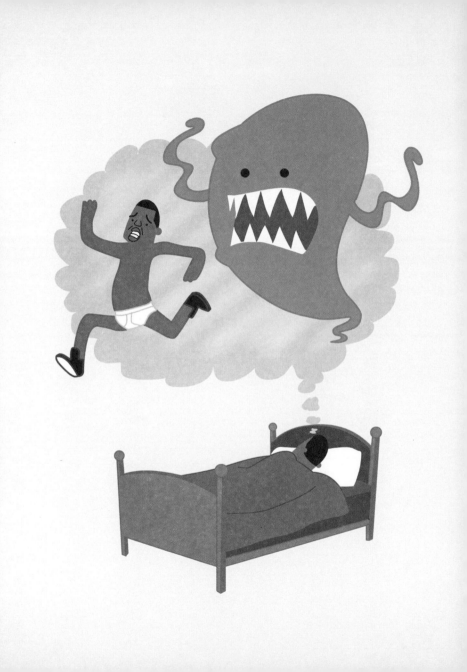

PROBLEM #39
SCARY DREAMS

PAPER CUTS

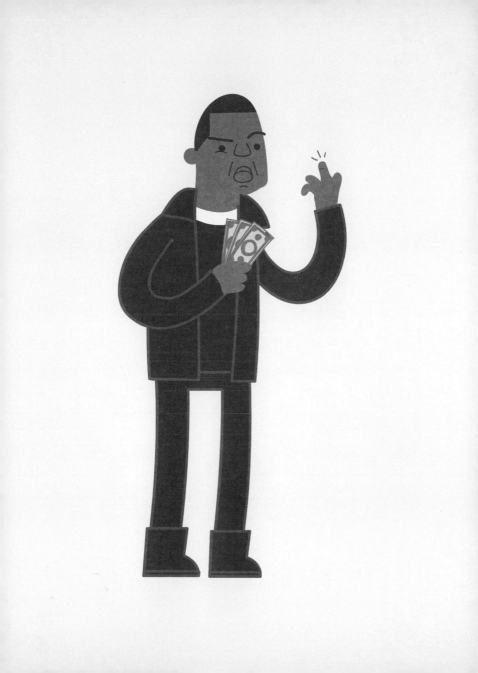

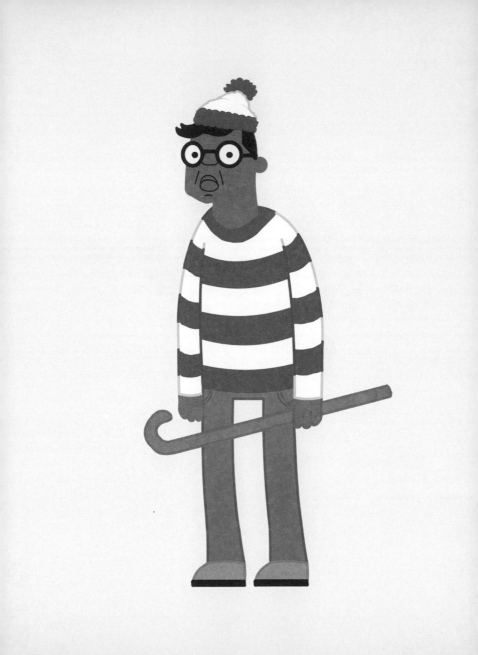

PROBLEM #41
TOO EASY TO FIND

I WANT TO BE FOREVER YOUNG

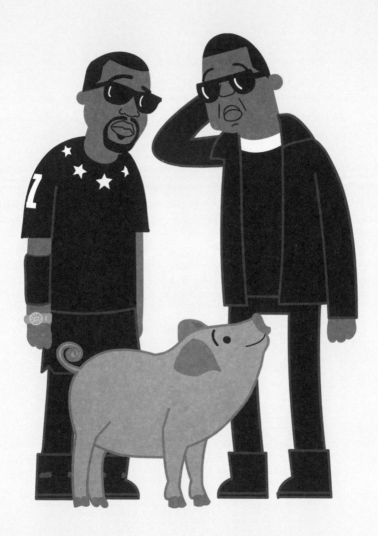

PROBLEM #43

I'M ABOUT TO GO HAM

PROBLEM #44

GRILLS, GRILLS, GRILLS

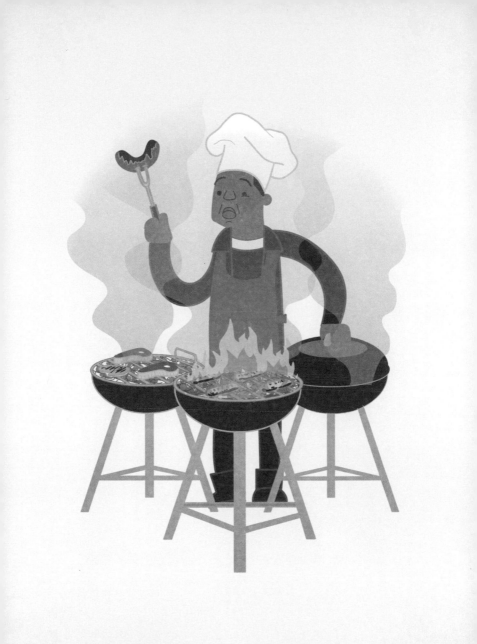

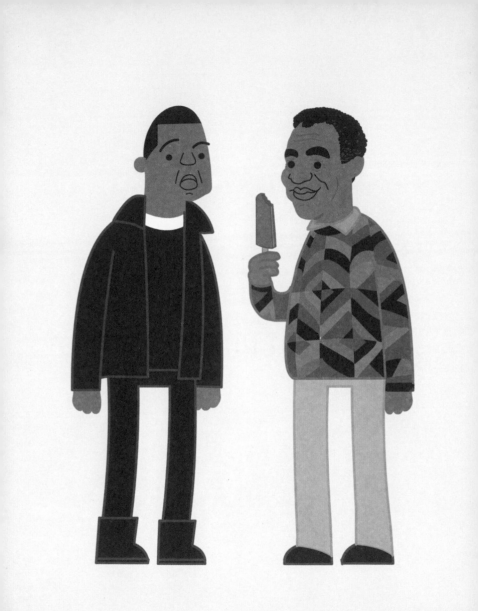

PROBLEM #45
AIN'T GOT NO PUDDING

RADIO DON'T PLAY MY HITS

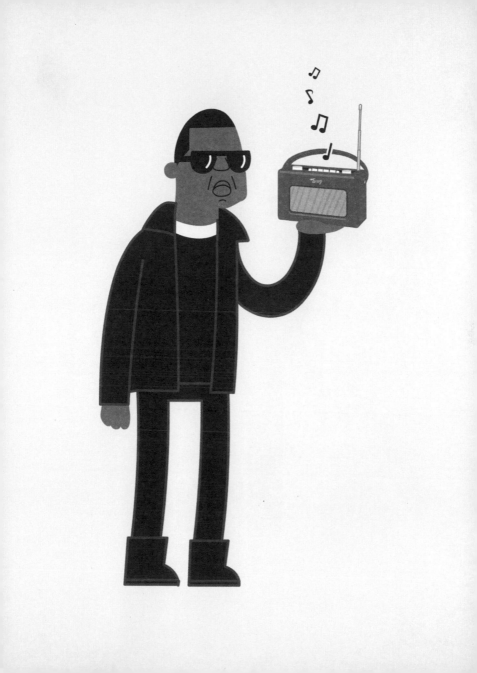

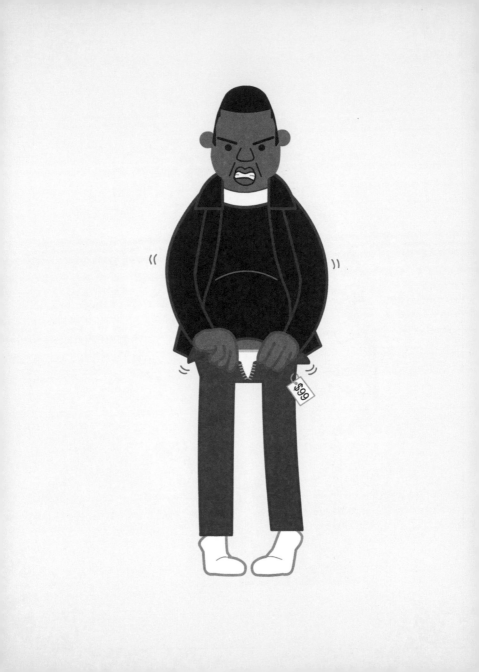

PROBLEM #47
CAN'T WEAR SKINNY JEANS

UNHAPPY

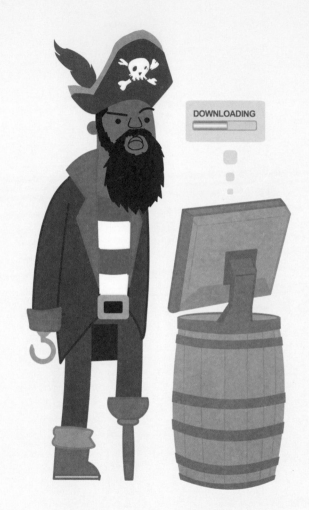

PROBLEM #49
PIRACY

PROBLEM #50
POWER'S OUT
(ALL BLACK EVERYTHING)

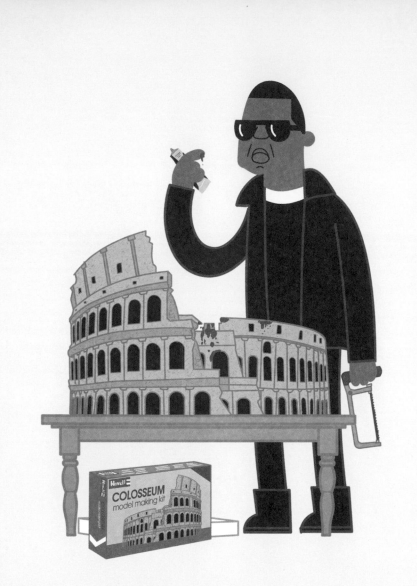

BLOOD STAINS THE COLOSSEUM DOORS

PROBLEM #52
CAN'T BRING THE FUTURE BACK

PROBLEM #53
OIL SPILLS

PROBLEM #54

HOW DO YOU TIE A BOW TIE?

PROBLEM #55
IT'S YOUR BUOY

SANDWICH SHORT OF A PICNIC

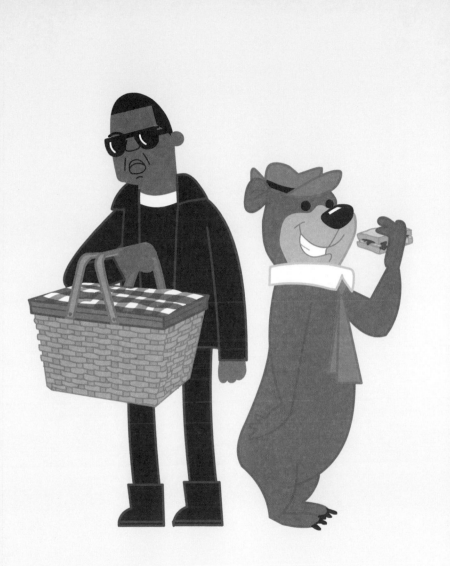

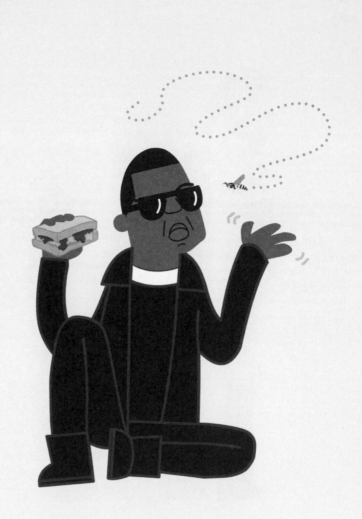

WASPS

PROBLEM #58
FRESH TO DEATH

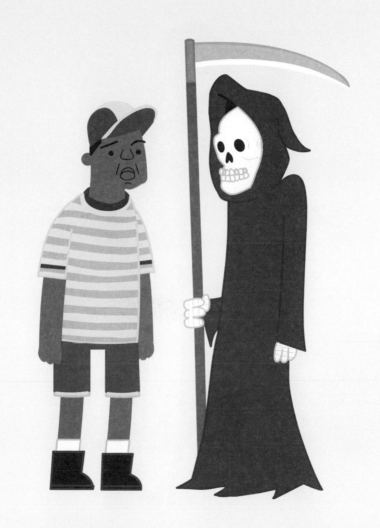

PROBLEM #59
ALLERGIES

LOST KEYS

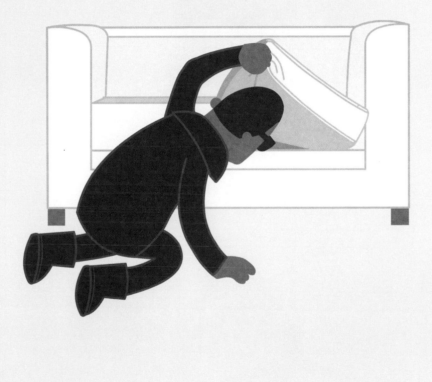

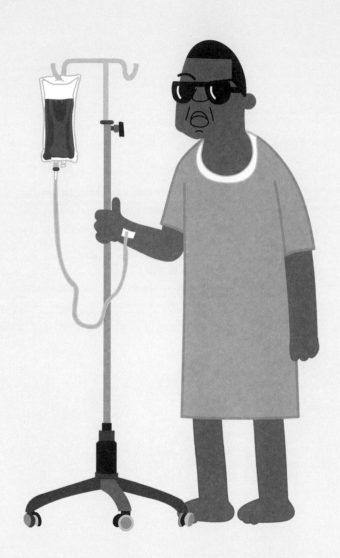

BLUE IV

PROBLEM #62

EMBARRASSING
PASSPORT PHOTO

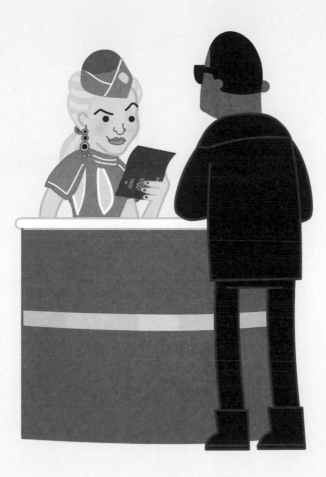

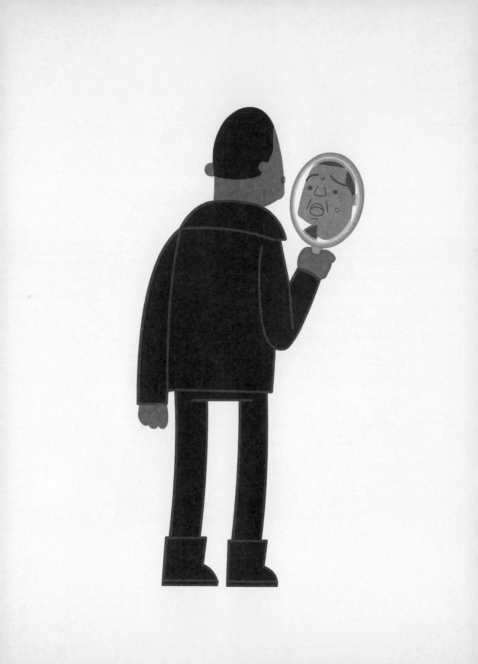

PROBLEM #63
BIG PIMPLES

PROBLEM #64
MAROONED

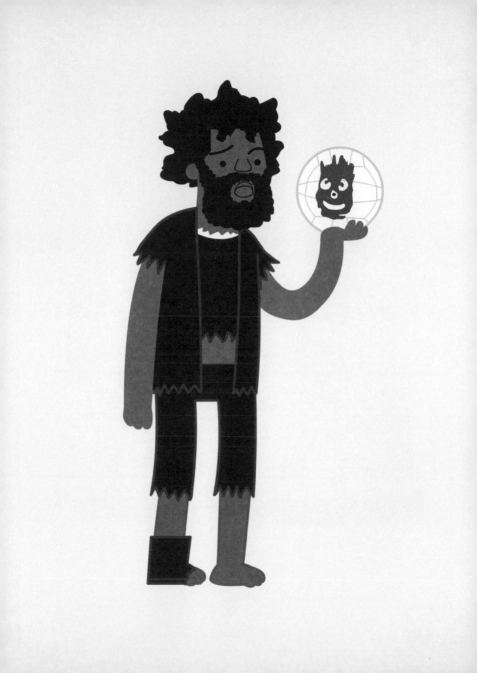

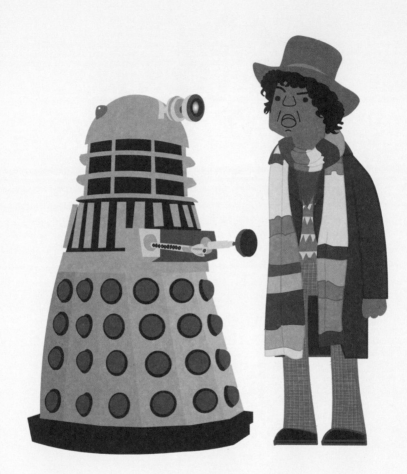

PROBLEM #65
EXTERMINATORS

DROPPED ICE CREAM

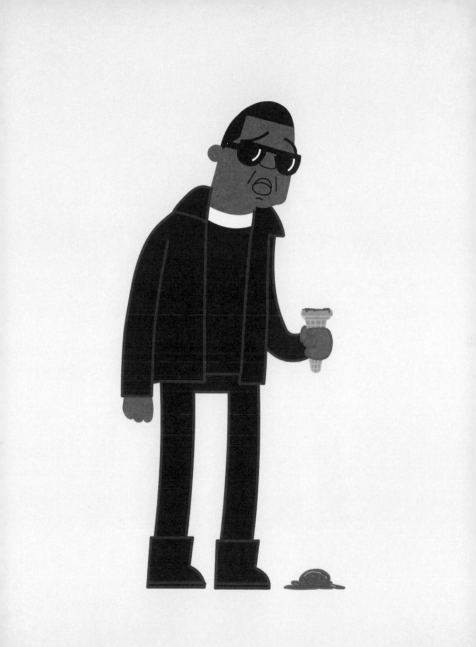

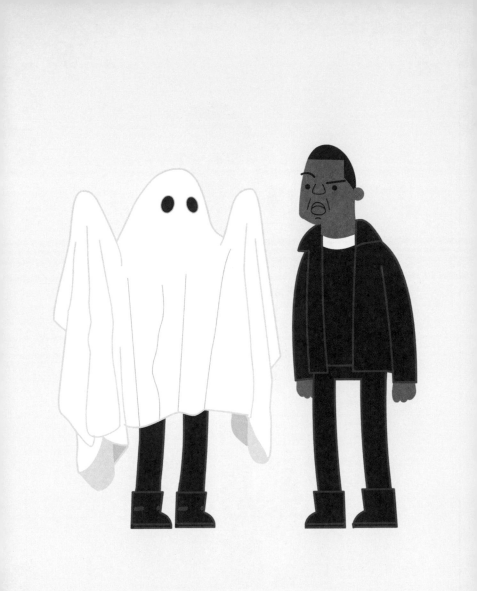

PROBLEM #67
THAT SHEET CRAY

PROBLEM #68
HASHTAGS

PROBLEM #69
I'M KILLING THIS ICE

PROBLEM #70
GOING TO JAIL

PROBLEM #71
TOO MANY HOES

PROBLEM #72
IDIOT WIND

PROBLEM #73
IT'S ABOUT TO GO DOWN

PROBLEM #74
OFF MILK

CAN'T CRACK YOUR CODE

PROBLEM #76
DISC NOT IN ITS CASE

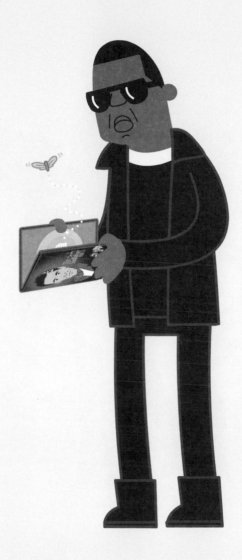

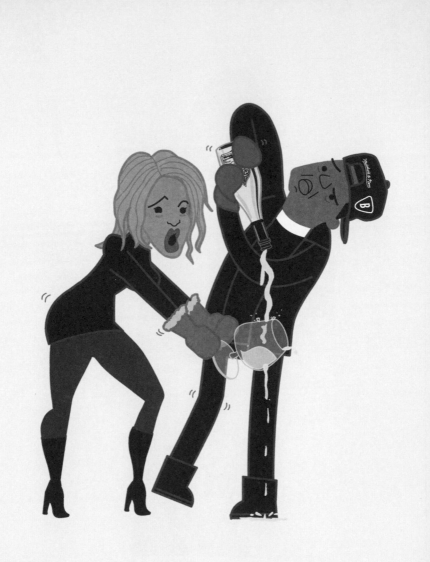

DRUNK IN GLOVES

ROOM FULL OF VULTURES

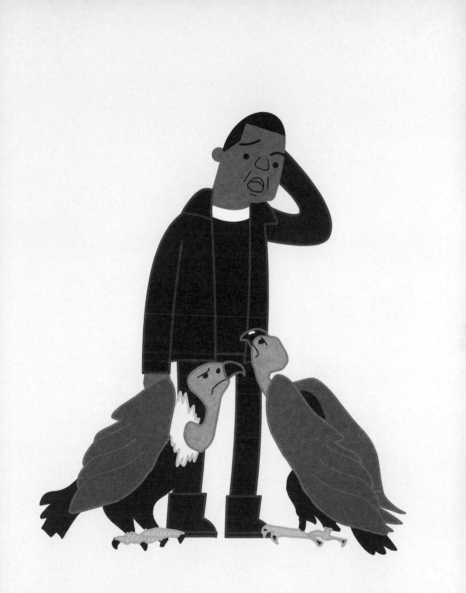

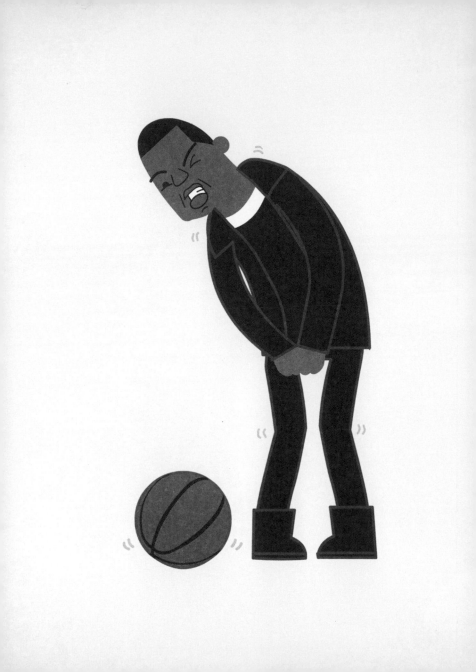

PROBLEM #79
BALL SO HARD

PROBLEM #80
HOLD YOUR APPLAUSE

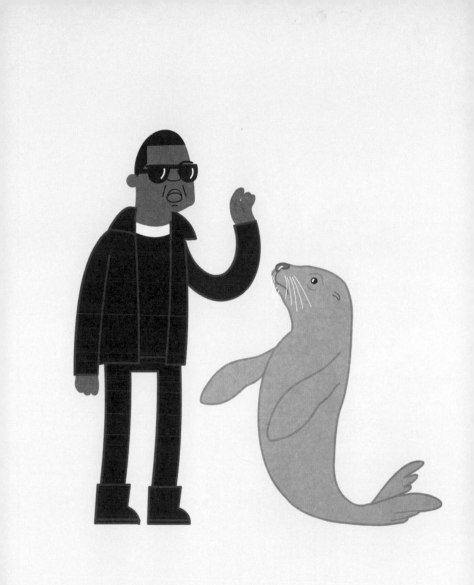

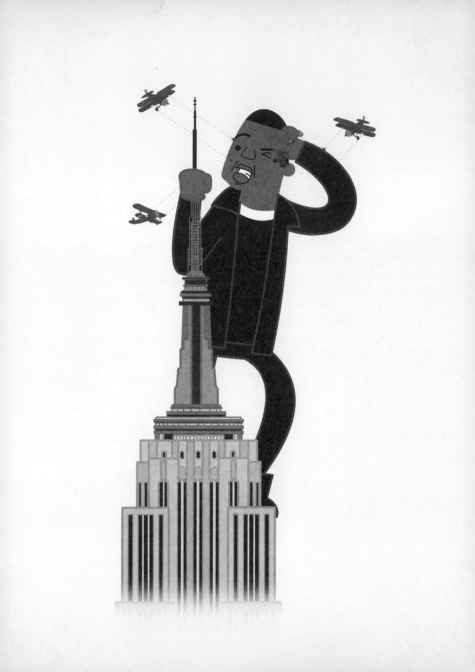

PROBLEM #81
NO SYMPATHY FOR THE KING

PROBLEM #82
CUP RUNNETH OVER

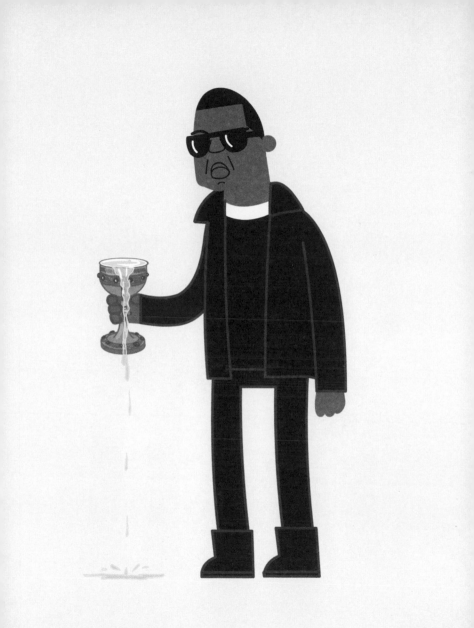

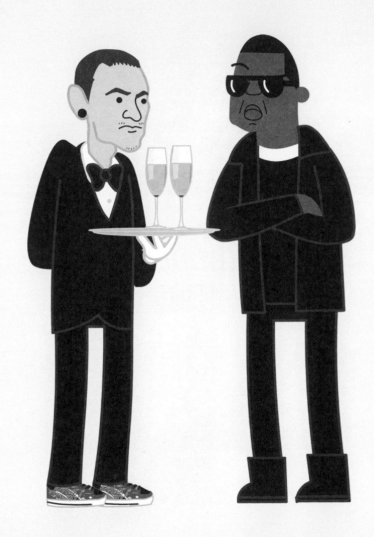

PROBLEM #83
WHAT THE HELL ARE YOU WAITING FOR?

GOT AN OUTLAW CHICK

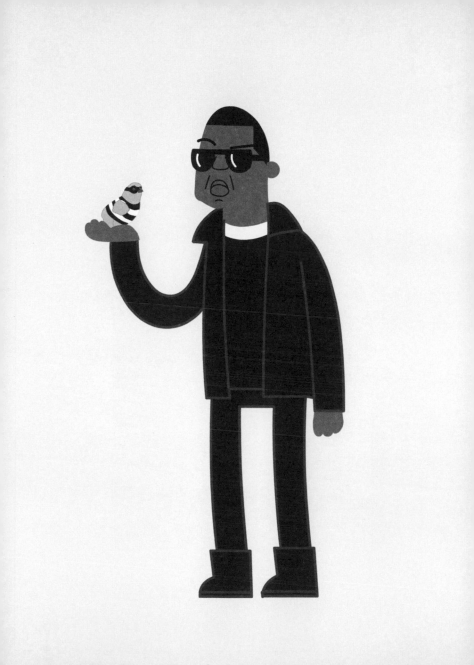

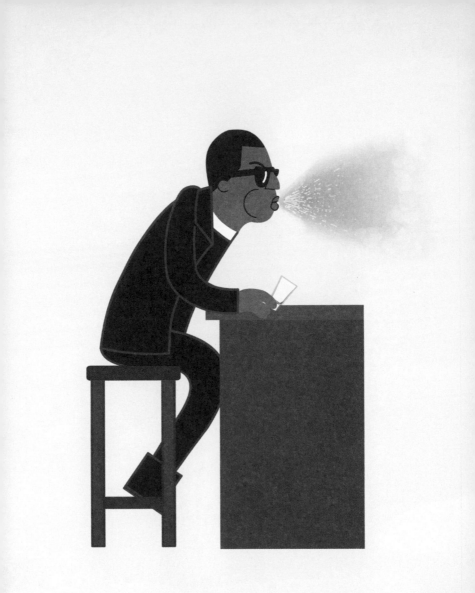

PROBLEM #85
SHOTS SPRAYED

STUBBED TOE

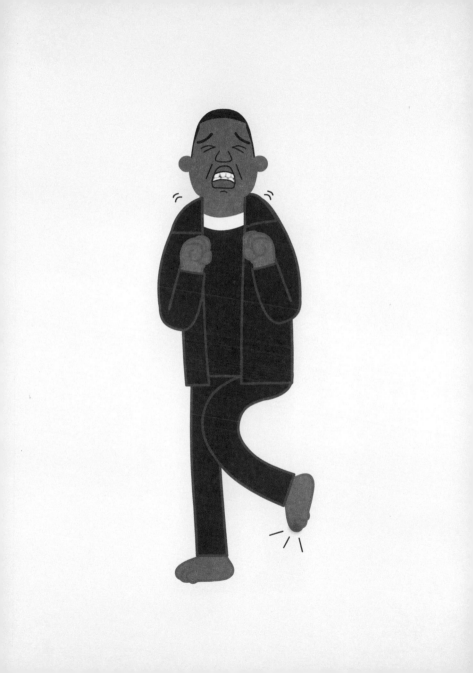

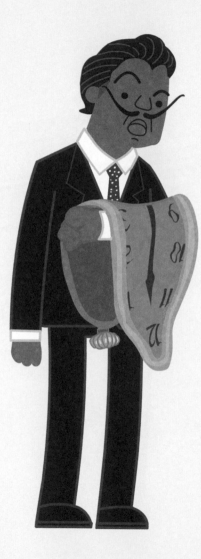

PROBLEM #87
GOT A BROKE CLOCK

PROBLEM #88
HUSTLER BABY

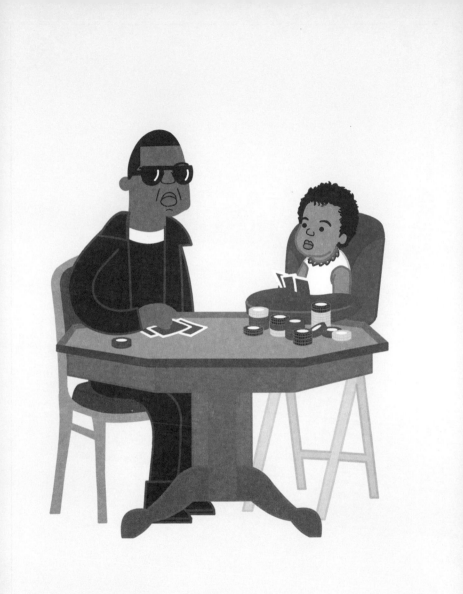

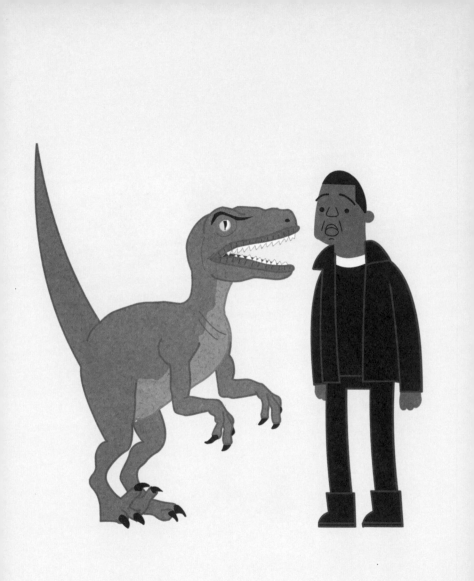

PROBLEM #89
LIFE FINDS A WAY

PROBLEM #90
TRICKY CROSSWORD

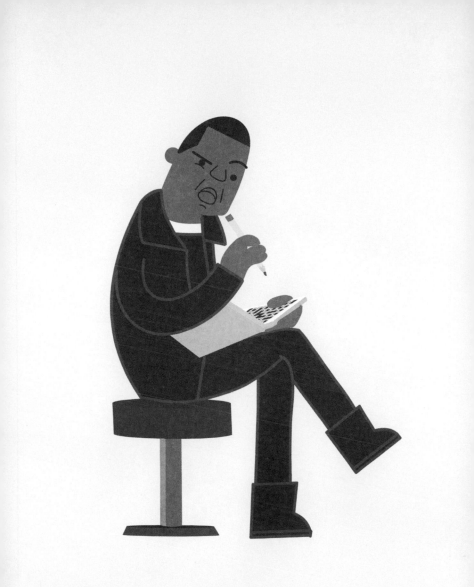

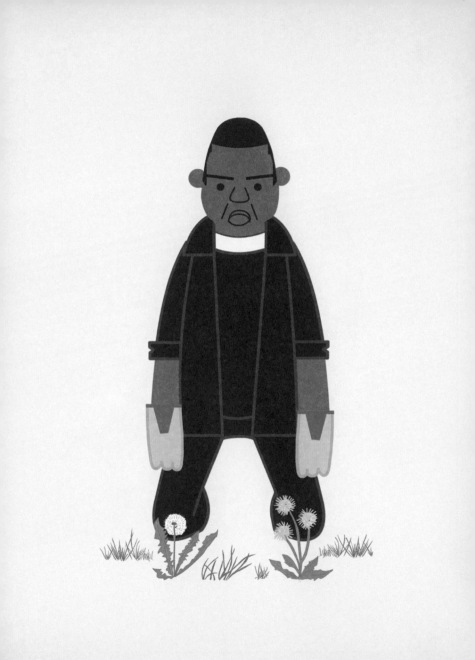

PROBLEM #91

GOT WEEDS EVERYWHERE

FLOW UNEARTHLY

PROBLEM #93
INTERRUPTIONS

FED'S STILL LURKING

PROBLEM #95
SMELLS LIKE TEEN SPIRIT

PROBLEM #96
BRAIN FREEZE

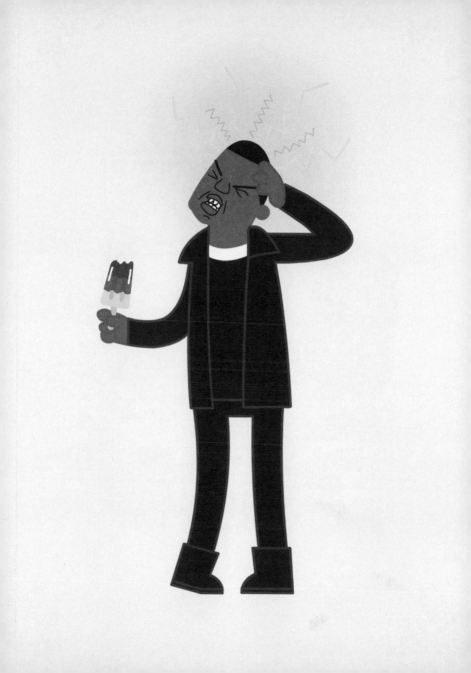

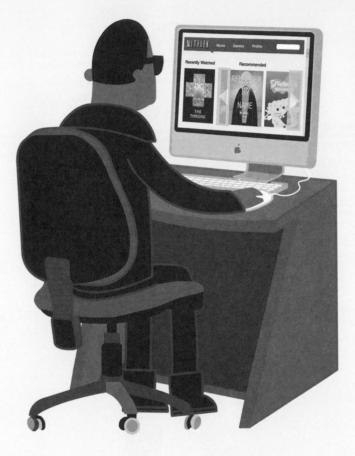

PROBLEM #97
TOO MUCH TO WATCH

PROBLEM #98
EXPECTATIONS

PROBLEM #99
WHAT MORE CAN I SAY?

ALI GRAHAM is an illustrator, filmmaker, and designer whose company, GrArG Media, provides visual marketing solutions to companies including Bobbi Brown, Estée Lauder, Michael Kors, Tommy Hilfiger, Pfizer, and others. He lives in Hastings, in the U.K., and online at grarg.com.